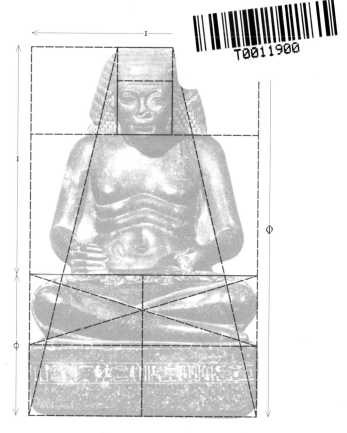

ABOVE: Statue of Royal Scribe and Architect Amenhotep
Son of Hapu, Luxor, Karnak. c.1370 BC. The statue forms
a Golden Rectangle, divided into a square over a smaller
quartered Golden Rectangle.

US edition © 2023 by Michael Schneider
Published by Wooden Books LLC,
San Rafael, California

First published in the UK in 2022
by Wooden Books LTD, Glastonbury

Library of Congress Cataloging-in-Publication Data
Schneider, M.
Proportion in Art and Architecture

Library of Congress Cataloging-in-Publication
Data has been applied for

ISBN-10: 1-952178-34-7
ISBN-13: 978-1-952178-34-4

Designed and typeset in Glastonbury, UK

Printed in China on FSC® certified papers by
RR Donnelley Asia Printing Solutions Ltd.

PROPORTION

IN ART AND ARCHITECTURE

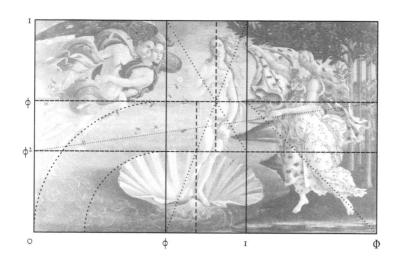

Michael Schneider

For

Leonard, Sally and Jeffrey
with Love

I'd like to thank many teachers and friends for their inspiration and information in this book, including John Michell, Keith Critchlow, John Martineau, John Neal, Adam Tetlow, Christine Rhone, Leon Conrad, Elaine Scheeter and my students at California College of the Arts. I was also influenced by the writings of Matila Ghyka, Jay Hambidge, L. D. Caskey, Charles Bouleau, Mabel Sykes, Rachel Fletcher and Steve Bass.

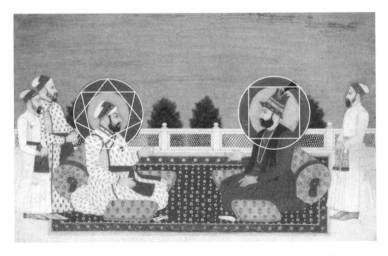

ABOVE: Muhammad Shah and Nadir Shah, 1740. *The differing proportions of their auras subtly inform us of their different natures.* TITLE PAGE: *The Birth of Venus, painted by Sandro Botticelli in 1486, forms a perfect Golden Rectangle (1: Φ), and many of its key elements can be further understood using golden rabatment (the addition or subtraction of a unit square). Note: throughout this book, φ = 0.618, and Φ = 1 + φ = 1.618.*

CONTENTS

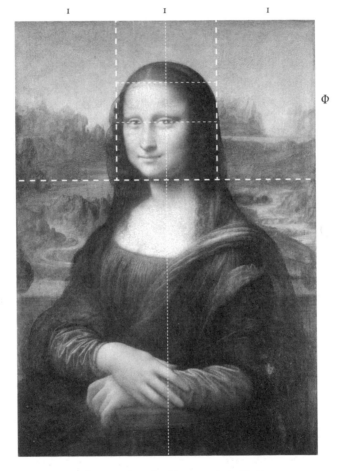

I I I

Φ

ABOVE: The Mona Lisa, painted by Leonardo da Vinci in 1503.
Three golden rectangles, with a square in the central one, frame her head in
the top of the picture. See if you can find the secret of her smile.

INTRODUCTION

MATHEMATICS AND ART can seem worlds apart. Modern art educators often warn against using numerical schemes and geometric ideas in creative work (cold water on passion). Yet many traditions, from the earliest civilizations onward, used symbolic number as a design tool in their great works of art, crafts, architecture. The intelligent and creative application of ratio, proportion, and harmony, expressed through geometry, can be seen in many ancient works, from the architectural and town planning canons of the c.500 BC *Vaastu Shastra* to many of the ancient great buildings, artifacts and illustrations around the world.

In countless cultures, mathematics was recognized not as a human creation but as the discovery of a sacred and philosophical language already inherent in the cosmos. Numbers were considered ambassadors from eternity, bestowing a divine gift upon humanity for the rational appreciation of creation, and revealing guidelines for our harmonious cooperation with it. In many traditions, a Divine Architect transformed dark chaos into this marvelously ordered cosmos by means of number, ratio and proportion merely using the tools of divider and straightedge.

Numbers represent formative powers, and nature displays this numerical canon from quarks to flowers to galactic clusters and beyond. Numbers and their ideal shapes and patterns were once considered *paradigma*, archetypes, the eternal models we see approximated in nature's marvelous architecture. Throughout history, civilizations have sought to move in accord with the teachings of this divine gift of mathematical wisdom by applying similar ideas to the harmonic and geometric designs of their arts, crafts and architecture.

MACRO-MESO-MICROCOSM
as above, so below, and in between

While modern cosmology studies the objects and motions of "outer space", traditional cosmology acknowledged, studied and celebrated the beautiful harmonious order of all of nature. To the ancient Greeks, the word *kosmos* signified "orderly arrangement, embroidery". This great universal order has been called the Macrocosm. And the human body, appearing to mirror the same archetypal principles of number and shape in miniature, was traditionally called the Microcosm.

The Hermetic maxim declares "As above, so below." But what happens between these? Cosmologically-ordered societies considered it imperative for the designs of objects made by people to echo this harmonious order too. This is the Mesocosm

("middle embroidery"). The built world of the arts, crafts, architecture, monuments, stele, music, song, chant, poetry, literature, law, medicine, religion, mythology, philosophy, ritualized landscapes, and even the organization of society were all made to reflect the harmony found above and below in the Macrocosm and Microcosm, three levels of cosmos as one grand harmony.

In traditions throughout the ancient world, the Mesocosmic built world of hearth and temple intermediates between human and cosmos (*e.g. see Francesco di Giorgio Martini's chapel floor plan, right*).

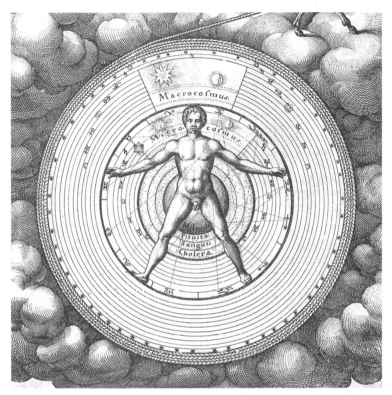

ABOVE: *Illustration of man, the microcosm, within the universal macrocosm, Robert Fludd, 1618.*

The MACROCOSM
the cosmos in a flower

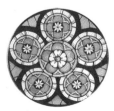

The MESOCOSM
the built world

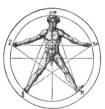

The MICROCOSM
the human, body & psyche

THERAPEUTIC ART
geometry as medicine

In many ancient traditions the role of art was different from today. Art was then designed to help us live in accordance with the world's and our own wellbeing, our wholeness, order and harmony. The power of art and proportion was seen as a form of medicine (disease being seen as the result of disharmony). The words *heal, health, whole* and *holy* share a common root, while the root *medi* signifies "to measure out", to find the middle, centre or just balance. Thus, architects, artisans, artists, musicians, singers and poets clothed harmonious numbers, patterns and shape relationships with plaster, line, colour, music and chant to contribute to the healing arts. In Egypt and Greece, painting was used to calm the emotions, music to purify the emotions and poetry to uplift the emotions.

Number is a gateway to beauty. The beauty we feel when viewing proportionately designed art and architecture was described by Socrates as the "shock of delight at *anamnesis*", a word literally meaning "re-minding" or "re-membering", a prompting towards remembrance of our own beauty and unity with the cosmos, a turn toward the radiant beauty within us, a deliverence from fragmentation to unity.

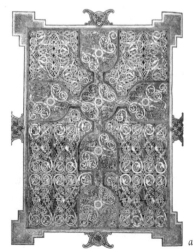

a.

4

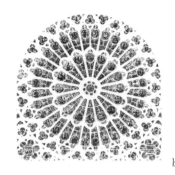

b.

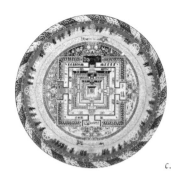

c.

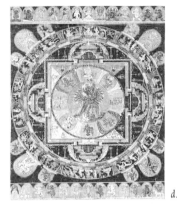

d.

THIS PAGE AND FACING: Examples
of proportional therapeutic art,
showing clear use of geometric and
harmonic principles. a. Carpet page
from the 8th century Lindisfarne
Gospels. b. North Rose Window of
Notre Dame de Paris. c. Kalachakra
"Wheel of Time" Sand Mandala. d.
Hevajra Mandala, Central Tibet,
14th century. e. Navajo Sandpainting
"Beauty Way". f. Navajo Sandpainting
"The Home of the Buffalo People".

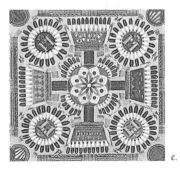

e.

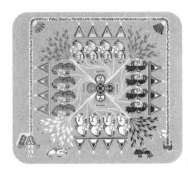

f.

MATHEMATICS IN DESIGN
harmony and geometry

There are three essential ways that mathematics has been marshaled as a tool for shaping the viewer's experience in traditional art and architecture, and this book is divided accordingly.

1. FIXED MODULES AND HARMONIC RATIOS. Artists and architects have long known that the same regular whole number ratios which please our ears in music also please our eyes in visible works. A set of "musical rectangles" representing these harmonics ratios can be found singing in the works of art and architecture of most cultures.

2. REGULAR POLYGONS. Triangles, squares, pentagons, hexagons, and so on, express geometric number ratios. Their organic subdivisions produce ongoing geometric proportions whose interplay reinforces the feeling generated by that ratio, especially when enclosed in a calm, perfect circle, the source of all ratios.

3. ROOT RECTANGLES. The canonical series of related "square-root rectangles" (*a, below*) and "golden rectangles" (*b*) emerge as the unfolding diagonals of rectangles derived of a square foundation, each with a different yet connected personality suited for visual design.

Harmonious patterns of number and shape thus serve the works of the cosmos and creative humans, as a shared natural design language.

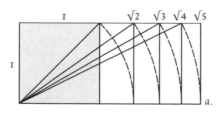

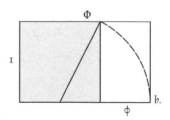

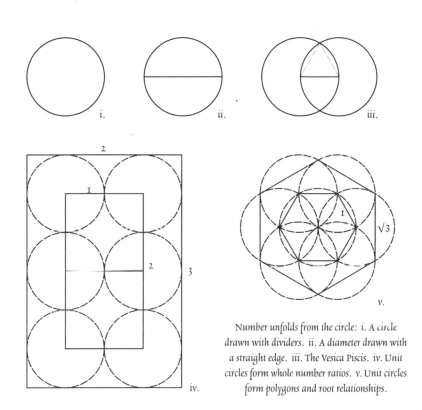

Number unfolds from the circle: i. A circle drawn with dividers. ii. A diameter drawn with a straight edge. iii. The Vesica Piscis. iv. Unit circles form whole number ratios. v. Unit circles form polygons and root relationships.

I 2 3 4 5 6 7 8 9 10 11 12

The numbers ONE and TWO represent unity and polarity, sameness and contrast, and are seen in the all-encompassing circle and its diameter. These are the core expressions of design in nature for artists, designers, and architects. The numbers THREE, FOUR, SIX, EIGHT, and TWELVE are structural; nature and humans build with them. Strong, balanced, and beautiful, they become the triangle, square, hexagon, octagon, and dodecagon. FIVE and TEN, represented by the pentagon and decagon, are numbers of life, adundant in the dynamic architecture of living nature. SEVEN, NINE, and ELEVEN are mysterious. Their polygons cannot be perfectly constructed with ruler and compass. They rarely appear in architectural design, although sacred art with heptagonal underpinnings can be found in almost every ancient culture.

STATIC AND DYNAMIC
multiplications and divisions

There are two compositional approaches in traditional art and architecture, in the ways that parts relate to each other and the whole.

Static, or rational, symmetry uses simple ratios of whole numbers. Any arithmetic or harmonic grid (*see page 14*) employs a rational module or standard unit of measurement (Roman *modulus*), a "building block", which can be added, subtracted, multiplied or divided into simple ratios to proportion the elements of a building, painting, sculpture, tiling or other work. In traditional modular architecture, this standard unit was the radius of the lower shaft of a column (*see opposite*).

Dynamic, or irrational, symmetry was described by Plato in the 4th century BC, and is based on the irrational number values which emerge from the angles and diagonals of geometric shapes. These impart rhythm, movement and aesthetic centers of gravity in ways that static design cannot. For example, the static 9 × 4 rectangle (ratio 2.25) found in Roman design is often mistaken for the more versatile dynamic √5 rectangle (ratio 2.236 ...) found in Greek design (*see below*).

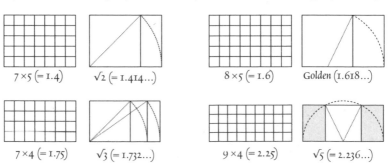

$7 \times 5 \, (= 1.4)$ $\sqrt{2} \, (= 1.414...)$ $8 \times 5 \, (= 1.6)$ *Golden* $(1.618...)$

$7 \times 4 \, (= 1.75)$ $\sqrt{3} \, (= 1.732...)$ $9 \times 4 \, (= 2.25)$ $\sqrt{5} \, (= 2.236...)$

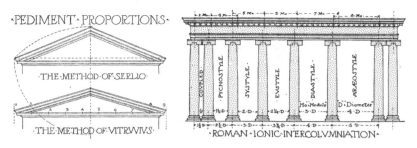

·PEDIMENT· PROPORTIONS·

·THE ·METHOD· OF· SERLIO·

·THE ·METHOD· OF· VITRVVIVS·

·ROMAN ~ IONIC· INTERCOLVMNIATION·

ABOVE: Serlio's pediment is determined by arcs to find the upper point. The first arc measures down on the centerline with a distance equaling one-half of the pediment width. From this point obtained as a center, the next arc connects the top of cornice – the base of the pediment – with the upper extension of the centerline. The point where the arc and the centerline intersect determines the pediment height.

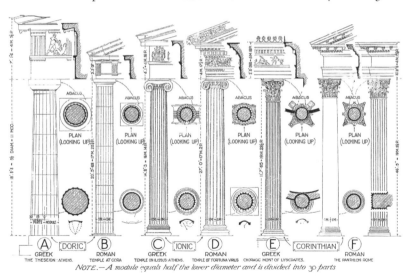

NOTE.— A module equals half the lower diameter and is divided into 30 parts

ABOVE: The classical orders of architecture, by Banister Fletcher, 1905, showing the Doric, Ionic and Corinthian orders in the their Greek and Roman forms. Using the diameter of the base of the shaft, Doric columns are 7 diameters high, Ionic are 8 diameters high, and Corinthian 9 diameters high.

FACING PAGE: Static whole-number approximations to some of the most common dynamic rectangles.

9

PROPORTION
the infinite in action

All things exist in relationship. Indeed, the mathematical word for relationship is *ratio* (Greek *logos*), a comparison, e.g. 1:2, "one to two". Its Indo-European root *ar-* ("fit together") appears in words like *art, arm, architecture, harmony, arithmetic, order, ornament, adorn, rhythm, ritual, riddle, rhyme* and *reason*. An *extended ratio* is a *proportion* (Greek *analogos*) "a ratio of ratios", e.g. 1:2::2:4, "one is to two as two is to four". A proportion is thus an ongoing set of identical growing or diminishing relationships whose harmonious rhythms can be sensed by a viewer.

Artists and architects use ratio and proportion to distribute and scale elements into agreeable relations with each other and the whole, to create *harmony* ("fitting together"), *symmetry* ("alike measure", or "commensurability of parts"), *rhythmos* ("recurring symmetry"), *balance* ("two scales") and *aesthetics* ("sensory beauty"). Proportional relationships provide contrast, resonance and rhythm to a work by allowing separate parts their full expression within an organic whole. Proportion is, finally, clothed with the earthly materials of art and architecture.

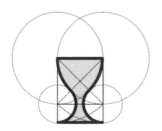

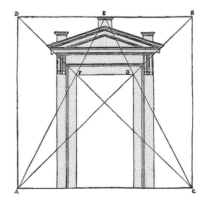

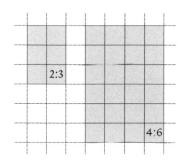

LEFT: An illustration of PROPORTION. The ratio 2:3 has the same proportion as the ratio 4:6. These two rectangles are essentially the same, differing only in scale. Proportion thus connects the shapes and sizes of things. Proportion also governs human nature, expressed via friendship customs, common laws and punishments, down here on Earth.

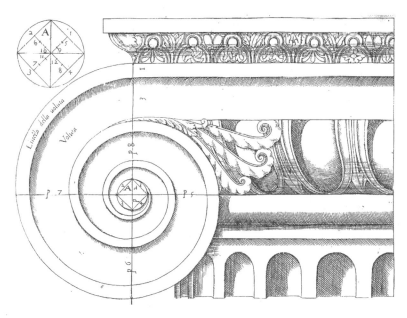

ABOVE: An Ionic volute spiral, showing the 'key' used to draw it (upper left corner). Later incorporated into the Corinthian order, such spirals were designed to invoke the exponential spirals of nature, from snails to galaxies, where any zoom or enlargement always produces exactly the same image, a simple illustration of the self-similar and unifying quality of proportion.

FROZEN MUSIC
the geometry of harmony

Since the Babylonian era and the time of Pythagoras [c.570–490 BC], we have known that the most pleasant musical harmonies appear as the most simple number ratios. The most pleasing sound of all is two instruments playing the same note in unison (1:1), or an octave apart (2:1).

The mathematical ratios of music depend on the way the octave is divided—into five, seven, twelve or more divisions. However, only four numbers are needed to produce the universal notes of the Pythagorean Tetrachord: the *Fundamental* (1:1), *Octave* (2:1), *Fifth* (3:2), and *Fourth* (4:3). Other perfect intervals used in art and architecture include the *Major Third* (4:5), the *Minor Third* (6:5), the Major 6th (5:3), the Minor Sixth (8:5), and the *Tone* (9:8, the interval between the fourth and the fifth, or between F and G on a piano).

For centuries, artists and architects have translated these mathematically simple and beautiful audible ratios into visible simple and beautiful relationships of length, area and volume, applied to everything from canvases, page layouts and stained glass windows to rooms and the great buildings containing them, to compose a "balance of balances" that "fit together" in visual harmony.

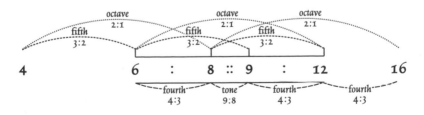

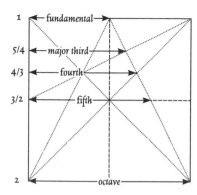

Values on the square diagram (top to bottom):
1 — fundamental
5/4 — major third
4/3 — fourth
3/2 — fifth
2 — octave

ABOVE: Harmony in a square, found in the crossings of diagonals and semi-diagonals. The essential harmonic intervals appear as frequencies, so higher notes are larger numbers.

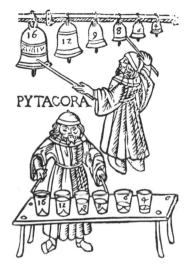

PYTAGORA

ABOVE: Detail from Theorica musicae, Franchino Gaffurio, 1492, showing research by Pythagoras on the nature of harmony, using bell-weights and glasses of water. Simple fractions make lovely harmonies. See opposite.

FACING PAGE: The unfolding of harmony. The octave (2:1), fifth (3:2) and fourth (4:3) define the structure of the scale. The difference between the fourth and fifth is the tone (9:8). The same numbers appear in the next diagram.

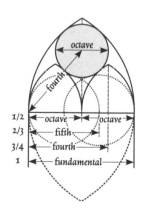

1/2 — octave · octave
2/3 — fifth
3/4 — fourth
1 — fundamental

ABOVE: Architecture as frozen music. The core harmonies as they appear in a church window. This diagram shows the harmonies as wavelengths, so shorter lengths are higher notes.

HARMONIC RECTANGLES
simple and complex

Art, architecture and music were traditionally designed to be sensible expressions of the order of the cosmos, and as such they share terms, including rhythm, harmony, proportion, texture, and articulation.

A proper education around the world in ancient times included the knowledge of mathematics and music. In China, along with knowing the proper construction of a calendar, construction of a harmonious musical scale was imperative for passing the civil servant examination. In the same way, the medieval European monastic "Liberal Arts" education (designed to liberate the soul from mundane attachments) included the Quadrivium ("four paths") of *Arithmetic* (the knowledge of numbers and their relationships), *Geometry* (numbers in space), *Music* or "harmonics" (numbers in time), and *Astronomy* (numbers in space and time). The comprehension of these four interwoven subjects was considered essential for any artist, designer or architect. Musical harmonies were translated into well-modulated symmetries of space, visual symphonies of geometry, clothed as art and architecture.

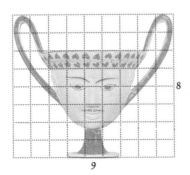

8

9

8

10

14

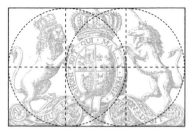
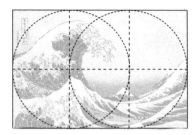

ABOVE: Two applications of the 2:3 rectangle. LEFT: Design for the Royal Coat of Arms of the United Kingdom, showing the use of the vesica in the design. RIGHT: The Great Wave off Kanagawa, by Katsushika Hokusai, 1830, uses a 2:3 canvas, with the waves echoing the geometry.

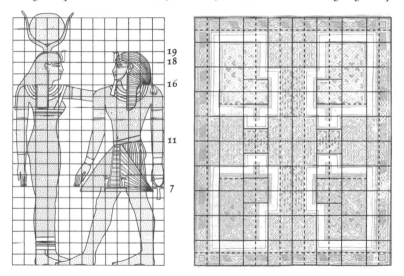

ABOVE: Two examples of formative grids. LEFT: The Egyptian grid system, evidence of which exists from the 3rd to 6th Dynasties, encloses the human figure in a 9:19 rectangle, with the eyes below the 18-line, the shoulders at 16, the belly-button around 11, and the fingers and skirt at the 7-line. RIGHT: Celtic carpet page from the 9th century Book of Kells, with a 8 × 10 (4:5) knotwork rectangle enclosing a 6 × 8 (3:4) keywork panel with a central 2 × 2 square. FACING LEFT: Greek Kantharos cup, in a 9 × 8 grid. RIGHT: Phoenician ivory relief, c.700BC, in a 10 × 8 grid.

HARMONIOUS PROPORTIONS
spatial symphonies

The Renaissance architect Leon Battista Alberti [1406–1472] recommended architects employ musical ratios in their designs of walls, facades and platforms, writing in his *Ten Books on Architecture*:

> *The very same numbers that cause sound to have that concinnitas, pleasing to the ears, can also fill the eyes and mind with wondrous delight. ... We shall therefore borrow all our Rules for the Finishing of our Proportions from the Musicians, who are the greatest Masters of this Sort of Numbers, and from those Things wherein Nature shows herself most excellent and compleat.* Los Diez Libros de Arquitectura, 1485

Alberti divided the most pleasing harmonic proportions into three groups: short, middle and long (*shown as three rows, opposite top*), advising they be used for the elevations of buildings.

Andrea Palladio [1508–1580], in his 1570 *Four Books of Architecture*, proposed seven sets of beautiful and harmonious proportions for use in the design of room plans, six of which reflect musical consonances. The height of a room, he said, should preferably be the *harmonic mean* of its length and width, so keeping every part of a room in harmony with its whole. All three means of antiquity are illustrated (*opposite*).

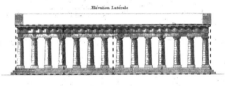

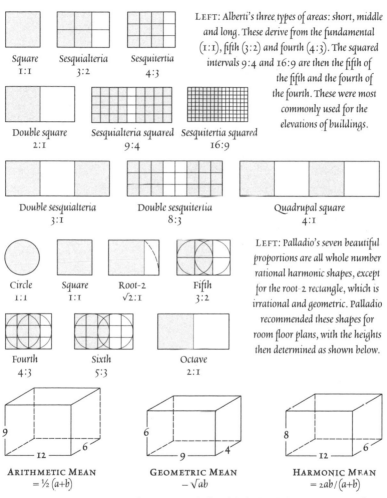

Square
1:1

Sesquialteria
3:2

Sesquitertia
4:3

LEFT: *Alberti's three types of areas: short, middle and long. These derive from the fundamental (1:1), fifth (3:2) and fourth (4:3). The squared intervals 9:4 and 16:9 are then the fifth of the fifth and the fourth of the fourth. These were most commonly used for the elevations of buildings.*

Double square
2:1

Sesquialteria squared
9:4

Sesquitertia squared
16:9

Double sesquialteria
3:1

Double sesquitertia
8:3

Quadrupal square
4:1

LEFT: *Palladio's seven beautiful proportions are all whole number rational harmonic shapes, except for the root-2 rectangle, which is irrational and geometric. Palladio recommended these shapes for room floor plans, with the heights then determined as shown below.*

Circle
1:1

Square
1:1

Root-2
√2:1

Fifth
3:2

Fourth
4:3

Sixth
5:3

Octave
2:1

ARITHMETIC MEAN
$= \frac{1}{2}(a+b)$

GEOMETRIC MEAN
$-\sqrt{ab}$

HARMONIC MEAN
$= 2ab/(a+b)$

ABOVE: THE THREE MEANS of Antiquity. *Palladio advised using the harmonic mean to fix the heights of rooms.* FACING PAGE: *The 420 BC Doric Temple at Segesta, Sicily, uses a 13 × 5 rectangle (2.6:1), a Fibonacci approximation to a Φ² rectangle (2.62:1), similar to Alberti's 8 × 3 (2.66:1).*

HOTSPOTS AND ALIGNMENTS
visual centres of gravity

A blank canvas is not empty. It is already filled with unseen proportional relationships. Points, lines, arcs, circles, squares, polygons and other devices drawn by a geometer, designer, artist or architect can reveal the geometric and harmonious relationships already there. These then become "regulating lines", "lines of tension", "visual centres of gravity" or simply "hotspots". Our mind expects to find something at one or more of these proportional hotspots and along certain lines.

Most people can tell when a point is at the centre of a circle or when a rectangle is actually a square. Look at a square and you will sense a subtle pressure from all sides inward towards the centre, whereas a wide rectangle has more pressure from above and below than from the sides. Creative artists, designers and architects control these pressures like a conductor organizing a symphony.

A skillful composition encourages a viewer's eye to move in rhythms along lines towards points and areas where attention should naturally come to rest, at the most important elements of a scene or structure (*see examples opposite*).

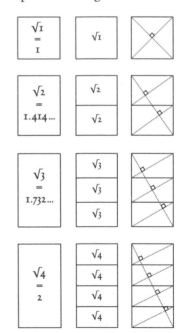

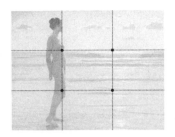
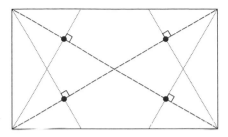

ABOVE LEFT: The RULE OF THIRDS, the division of a canvas into three, horizontally and vertically, creates four harmonic regulating lines and four hotspots, as shown here in the precise positioning of a figure and the horizon in Max Nonnenbruch's 1920 painting Madchen am Strand. ABOVE RIGHT: The four OCCULT CENTRES of a rectangle are four hotspots found using the two diagonals and their perpendiculars through the corners. They are used in both art and architecture.

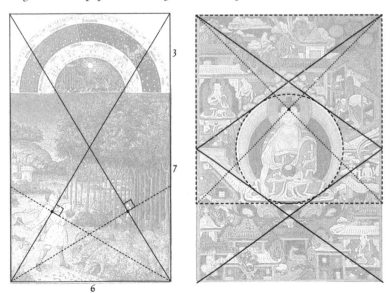

ABOVE LEFT: 3 × 5 illumination from Les Tres Riches Heures of Duc du Berry, 1416, with two characters positioned at two occult centres. ABOVE RIGHT: Buddhist Thangka painting, showing key formative guides. FACING PAGE: Compound and occult relationships within Root rectangles.

REGULAR POLYGONS
the masks of numbers

The word *polygon*, from the Greek *poly-gonia*, or "many knees" (corners or angles) refers to an enclosed two-dimensional shape made of points, line segments and angles enclosing an area. Regular polygons have identical angles (*equiangular*) and equal length sides (*equilateral*). They are dispersed throughout nature and have been intentionally applied to art and architecture across countless cultures for centuries.

Each polygon offers particular practical benefits, symbolic associations and its own aesthetic feel (*see below*). Some polygons excel at shoring up static structure, some bestow their benefits to dynamic, living forms and technology, and others are associated with topics of mystery.

A polygon is a simple whole number expressed in the guise of space. The personality of each polygon comes from its essential numerical properties which give rise to its geometric abilities. Its fixed internal ratios and proportions determine whether it can tile in 2D (the triangle, square and hexagon), or form solids in 3D (the triangle, square and pentagon), or only overlap to form other regular/irregular shapes.

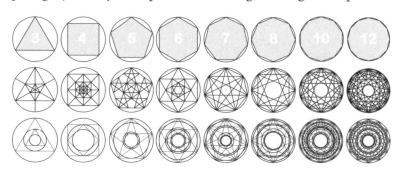

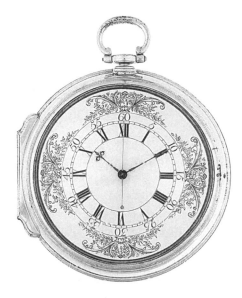

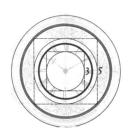

LEFT: John Harrison's famous Sea Watch No.1, 1759, designed to help sailors find their longitude. Clock faces are ideal canvasses for polygonal design as they are already circular and divided into 3-4-6-12. Harrison proportions the circles of his design using two squares, sizes 3 and 5.

LEFT: A curious feature of many Ancient Greek decorated plates is that the figures stand on a floor-line whose length and height are both fixed by an invisible polygon. Examples are shown for the first five polygons.

AD TRIANGULUM
divine balance

The equilateral triangle is the simplest regular polygon, the first to enclose space with straight lines. For practical and symbolic reasons the number three and its triangular mask appear frequently in the arts, crafts, architecture, religion and mythology of countless traditions.

A divided equilateral triangle reveals nets of proportional hotspots, centres of visual gravity used in traditional compositions. The triangle's √3 ratio harmonizes diverse parts into a whole, its self-similar pattern conveying unity, stability and strength, from molecules to monuments.

A triangle drawn inside a circle radius 2 encloses another circle radius 1, the musical octave. Having the same perimeter, a circle encloses the most area while a triangle encloses the least, and the two together reveal a symphony of happy harmonies in radii and areas (*below*). These resonant relationships contribute to the delight we feel at seeing well-applied triangular design.

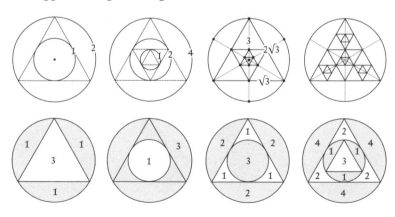

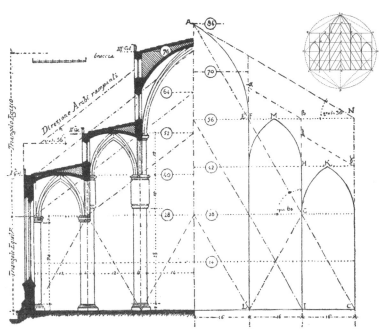

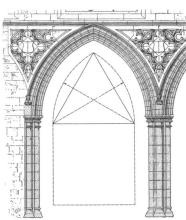

ABOVE: Cross-section of Milan Cathedral, Italy, 1386 (left), compared with the original scheme as designed by Gabriele Stornaloco (right), based on a grid of nested equilateral triangles and triangular arches, framed in a hexagon (inset). LEFT: Triangular arch.

TRIANGULAR PROPORTIONS
the middle path

The term "trinity" or "tri-unity" describes a three-part oneness: two opposites and their balance bonding as a single whole. Each side of a triangle also serves as a diagonal, resisting, reinforcing and balancing the other two. The triangle is the strongest, most compact shape in two dimensions and so has forever been at the foundation of natural and human architecture and designs. Stable physical structure requires spatial triangulation. This property in an arch deflects weight down from the keystone to forge a strong, stable whole, and so is found in the designs of windows, bridges, towers, flying buttresses, cathedrals, pyramids and anywhere elegant strength, stability, balance and are called for.

Along with physical strength and balance, the equilateral triangle can convey feelings of uplift and inspiration, even spiritual transcendence. It does so by resolving and rising above duality, uniting opposites into a new whole they couldn't achieve by themselves. Thus, the triangle recurs as a worldwide symbol of divinity and the sacred middle, a transcendent path beyond the tumult of mundane extremes.

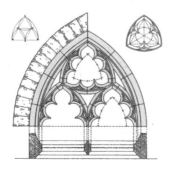

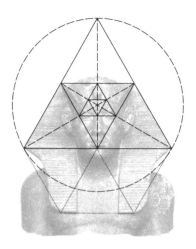

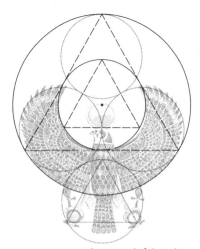

ABOVE: LEFT: Bust of Pharaoh Amenemhet III, c.1500BC. RIGHT: Falcon pectoral of Pharaoh Tutankhamun, 18th Dyansty, c. 1332 – 1323 BC, showing use of triangular geometry in the design.

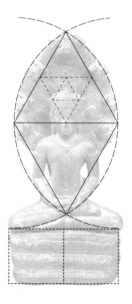

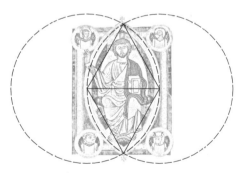

LEFT: Meditating Buddha, 12th C, Cambodia. ABOVE: Christ in a Vesica, illumination from the Codex Bruchsal, c.1220. FACING PAGE: LEFT: Triangular arch with triangular tracery. RIGHT: Ancient Greek kylix (wine cup), c.500BC. Note that the inner circle enclosed by a triangle is half the size of the outer enclosing circle, a musical octave.

AD QUADRATUM
an earthly foundation

The square is the simplest regular polygon. It has four right angles. Its geometric construction was known in ancient India by 3000 BC and used in rituals of the four directions, creation of sundials, and the design of fire altars and temples. The diagonals of a square are $\sqrt{2}$ times the length of any side. Connecting the midpoints of a square's sides crosses its diagonals to reveal an ongoing proportional net of decreasing areas and lengths that maintain the same $\sqrt{2}$ and halving ratio through a diversity of sizes (*shown below*). Double, triple and other multiples of squares are found in design (*e.g. see page 50-51*).

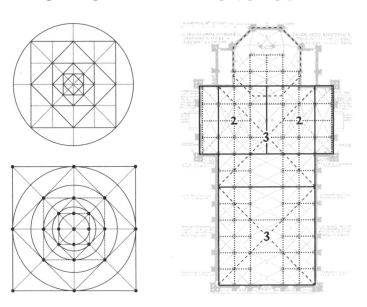

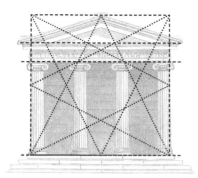
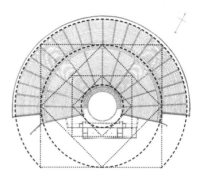

ABOVE LEFT: *Greek Temple with 'Starcut' overlay. Notice how the entire temple fits in a square.*
RIGHT: *Greek Theatre of Epidaurus, 4th C. BC, showing the use of root-2 square proportions. In great architecture, look for the square which serves as the central seed of the entire geometric design.*

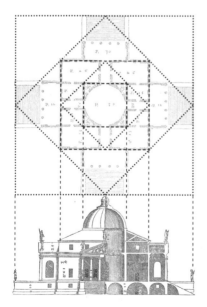

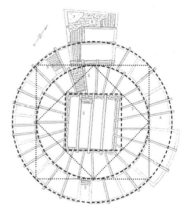

LEFT: *Villa Rotunda, original 1570 design by Andrea Palladio.* ABOVE: *Native American kiva roof frame.* FAING PAGE, *Ad Quadratum plan of the Duomo, Milan. Contrast this with its Ad Triangulum elevation, shown on page 23.*

SQUARE PROPORTIONS
the perfect dinner plate

Designers appreciate that a square scribed between two circles divides the entire area into equal halves: the area of the outer ring equals the area of the inner circle (*below, centre*). This attractive, balanced scheme is found in the design of plates of most every culture.

With four equal sides and right angles the square has long been a symbol of equality and justice, being fair and square all around. It also orients us to the four cardinal directions of space and the four seasons of time, and reminds us of the four states of *matter* (from the Latin *mater*, mother, also *matrix* and *measure*). The square has thus been a worldwide symbol of the Earth, the material world and the archetypal feminine, the *genetrix*, since the dawn of time. It is primal in the art and architecture of earth-centred societies, from goddess art to the divinatory origins of board games.

The ideal realm which corresponds to the material realm is the world of *pattern*, the word coming from the Latin *pater*, father. Nature displays matter in patterns—and aspiring artists and architects attempt to do exactly the same.

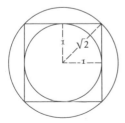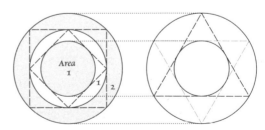

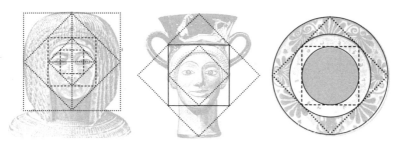

ABOVE: LEFT: *Egyptian canopic jar lid, depicting Kiya, second queen of Akhenaten c.1340BC.* CENTRE: *Greek drinking cup, c. 480BC.* RIGHT: *Ancient Greek vase, as seen from above.*

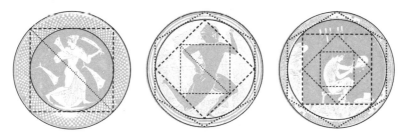

ABOVE: LEFT: *The Greek Neried Thetis holding dolphins, 6th C BC.* CENTRE: *Greek kylix tondo painting depicting a runner.* RIGHT: *Attic cup depicting a helmet-maker, c.480BC, by Antiphon.*

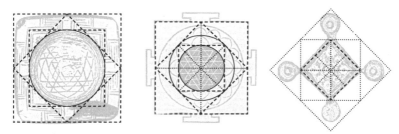

ABOVE: LEFT & CENTRE: *Ancient Indian Sri Yantra diagrams.* CENTRE: *Gallic Celtic Brooch, c.200AD. Note how these objects employ square geometry to unify their design elements.*

PENTAGONAL PROPORTIONS
the art of life

The regular pentagon has five equal sides and 108° internal angles. It is the first polygon to allow its diagonals to be drawn without lifting the pencil from the page, forming a pentagram star which naturally crosses itself into golden ratio sections (*below, top left*), continually regenerating miniature and larger models of itself as a classic fractal. These crossings reveal a nested web of golden ratio proportioned points, lines and areas of interest, which appear in countless designs worldwide.

With a few molecular exceptions, pentagonal symmetry appears predominantly in living forms like starfish and flowers which take advantage of its dynamic, regenerative geometry. In the traditional arts, crafts and design worldwide it is used as symbol and a compositional tool where feelings and ideas regarding regeneration, rebirth, vitality and the exuberance of life are appropriate, as well as humanness, excellence and righteous authority.

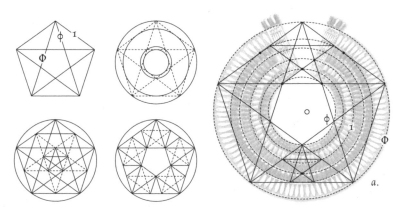

a.

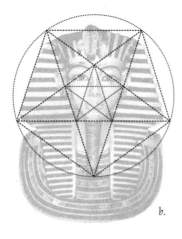

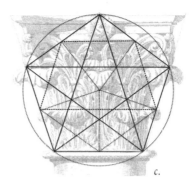

c.

e.

b.

d.

a. Egyptian broad collar; b. Gold mask of
Tutankhamen; c. Greek Corinthian capital;
d. Raphael painting; e. Arabic calligraphy;
f. Mayan plate; g. First Day of Creation,
Nuremburg Chronicle; h. Greek canteen.

f.

g.

h.

HEXAGONAL PROPORTIONS
structure and space

Six is a number of structure, and a regular hexagon contains six internal 120° angles bracing six equal sides of six equilateral triangles. Its ubiquity in nature, architecture and technology derives from its relation to the triangle. Diagonals connecting its semi-adjacent corners create the two interpenetrating triangles of a hexagram star, the central hexagon implying an endless net of alternately rotated hexagrams and hexagons diminishing towards its centre (although some traditional designs nest hexagrams without rotation).

Like the equilateral triangle, the hexagon is a perpetual fountain of √3 ratios, whose sub-areas compose a visual symphony of simple ratios and a proportional net of possibilities with more complex opportunities for harmonious composition than a single triangle.

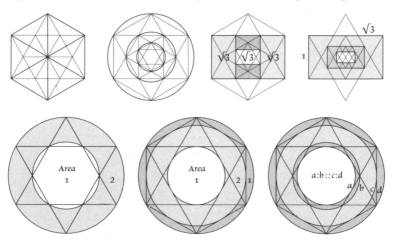

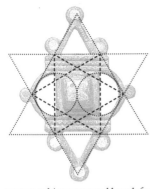

ABOVE: Celtic Ornamental brooch from
Roman Gaul, c.200 AD.

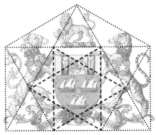

ABOVE: Ritual Chinese jade Bi disc with
Dragon Motifs, Jincun, Henan, c.500 BC.

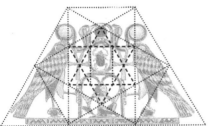

ABOVE: Pectoral of Princess Sithathoryunet,
Middle Kingdom, 12th Dynasty, c.1880 BC.

ABOVE: 19th century heraldic design, from
Mumbai, India.

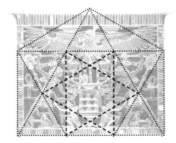

ABOVE: Pectoral of Princess Mereret, 12th
Dynasty, Egypt, c.1820 BC.

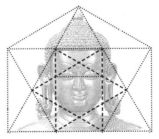

ABOVE: Head of Buddha, Nepal.
FACING PAGE: Sixfold geometry.

HEPTAGONAL PROPORTIONS
a shape of mystery

Seven is the premier number of mystery. A circle cannot be perfectly divided into seven equal parts with the traditional tools of compass and straightedge. Like the seven-part rainbow or the seven notes of the diatonic scale, sevenness avoids being held in our hands. Seven has long been associated with abstraction, of that which is transcendent, sacred, spiritual—of a knowing born of imagination beyond mere logic. Thus, museums worldwide are filled with sacred art, ritual vessels, plates, bowls and statuary of deities associated with the number seven.

The angles of the regular heptagon and its two heptagram stars are unwieldy for general building, but have been used to enhance crossfire defences in forts (*e., opposite*).

While heptagonal proportions do not engage in whole number relationships, they nevertheless have their own uniquely appealing quality, suggestive of eternal motion, lending a restless, transcendent feeling to anything they are applied to.

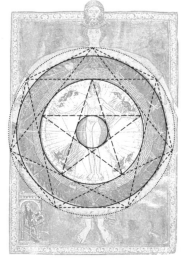

a.

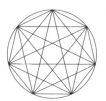
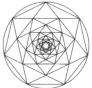

34

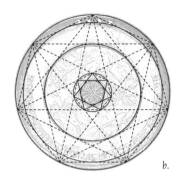

b.

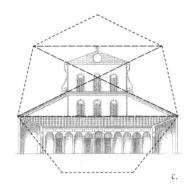

c.

a. The Universal Man, illumination from the Liber
Divinorum Operum of St. Hildegard of Bingen,
1165; b. Egyptian patera (libation bowl), from
Tanis, Tomb of Psusennes, c.1000 BC); c. Facade
of ancient Basilica of St. Peter, built by Constantine;
d. Native American Hopi bowl of seven bear paws.
e. Heptagonal bastion fort, Coevorden, Netherlands,
17th century; f. Ring flask from Abelh Beth
Maacah, ancient Israel, c.1200 BC.

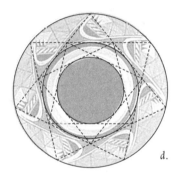

d.

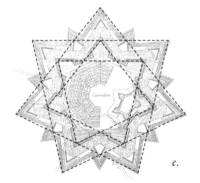

e.

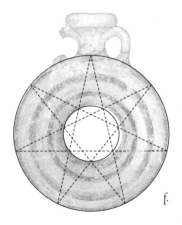

f.

OCTAGONAL PROPORTIONS
between heaven and earth

Eight is a number of structure, so its geometric form, the regular octagon, appears in the art and architecture of every tradition. At its heart the octagon expresses the same √2 ratio found in the square, but more elegantly. An octagon's 135° corner angles relate to the square's 90° angles by the ratio 3:2, the musical fifth, so both shapes are often found working together in harmony. Its different octagram stellations generate harmonious √2 proportions endlessly inward.

The circle and the square are arguably the most important elements of art and architecture. The octagon can be understood as a square which has been turned by a quarter-circle to overlap with itself, resting halfway between the circle, symbol of the vault of Heaven, and the square, symbol of the "four corners" of the Earth. Octagons and octagram stars in architecture reflect the interface between heaven and earth, under scrutiny by both. The trinity of a circle, cone or sphere above, a square below, and an octagon between them appears in the design of countless sacred and secular domed buildings.

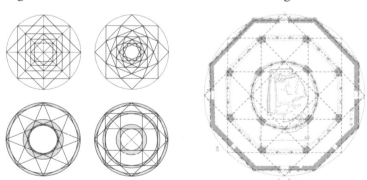

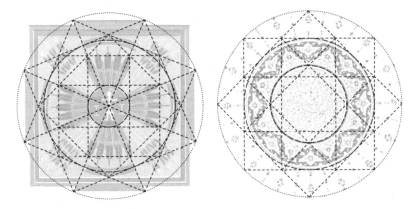

ABOVE LEFT: *Traditional Navajo (Dineh) sandpainting.* ABOVE RIGHT: *Detail from Shiraz Qu'ran, 16th C.* BELOW LEFT: *Tibetan thangka painting, esoteric form of Vajrapani (protector and guide of Buddha), 15th century.* BELOW RIGHT: *"Breath of the Compassionate" Persian Islamic tile, 1262 AD. The full pattern, shown beneath, consists of a tiling made of alternating "exhaling" and "inhaling" octagons.* FACING PAGE: *Plan of the Dome of the Rock, Jerusalem.*

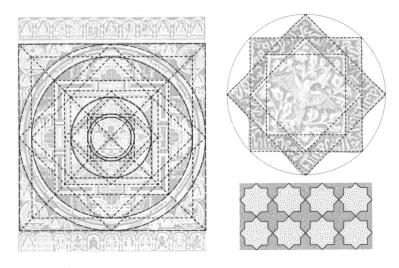

TEN AND TWELVE
the two great systems

The number ten, like five, is primarily found in living forms. A regular decagon generates three stellations whose proportions weave complex arrangement of points, lines and areas, from tilings to rose windows (*below*). Decagonal space reveals harmonious golden ratio relationships which many artists and architects have clothed with rich designs.

Ten represents the full realization of the potential of the One. It was central to the spiritual philosophy of Pythagoras, represented by the Tetractys (a triangle of ten points), and it occurs as the ten emanations of the Jewish Kabbala's Tree of Life.

The number twelve is the supreme number of structure in two and three dimensions, composed of other numbers of structure, 3, 4 and 6. Thus, its internal dodecagonal stars reveal the proportions of four triangles, three squares or two hexagons, allowing the artist and architect to work with the square-root ratios of 1, 2, 3, and 4. In this way, twelvefold symmetry lends itself to the most complex interplay of ratios and harmonious proportions (*opposite*).

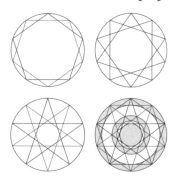

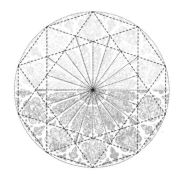

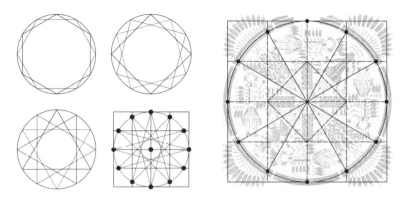

ABOVE LEFT: *Internal geometry of the dodecagon (Greek: "two-plus-ten knees"), showing how it is formed of two hexagons, or three squares, or four triangles. In 3-D the dodecagon blossoms into the twelve-faced dodecahedron ("two-plus-ten seats"). ABOVE RIGHT: Navajo Whirling Log design.*

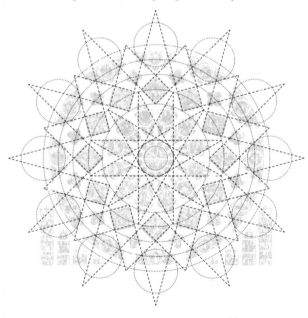

LEFT: North rose window, Chartres, France, c. 1200 AD showing 12-fold geometry. Dodecagonal symmetry is characteristic of the arts, crafts, architecture and designs of cosmologically-ordered societies where the musical, religious, mythological and astronomical symbolism of "twelve-around a-center" played a prominent role.

FACING PAGE: West rose window, "Creation", National Cathedral, Washington DC, 1976. The symmetry of interpenetrating regular pentagons or pentagrams, supports ideas of human interplay and cooperation.

CANONICAL RECTANGLES
ratios made visible

The word "canonical" signifies a body of knowledge, a standard according to rule of law. It derives from the Babylonian-Assyrian *kanu*, a cane, reed, rod, radius or measuring rule standard, which later became the Greek word *kanon* signifying a "model". The root "*ank-*" in a word signifies that it is "bent", as in *angle*, *ankle* and *anchor*. The term "canonical rectangles" therefore refers to a family of intimately related dynamic rectangles whose divisions and subdivisions orchestrate a wide range of subtle proportions into a harmonious whole. Canonical rectangles organize space in two particular ways:

Irrational (or "square root") rectangles begin with a square foundation and expand beyond (and within) it through a growing woven sequence of "square roots" of numbers.

Rational (or "harmonic") rectangles use whole numbers on their sides, and reflect to the eye the number ratios which are so pleasant to the ear as the harmonies of music (*see pages 12–17*).

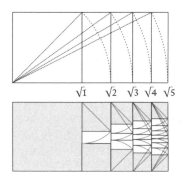
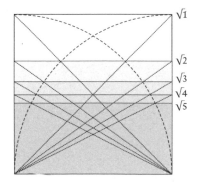

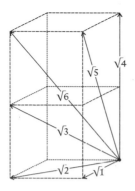

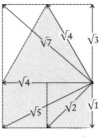

ABOVE: Root proportions appear naturally in two and three dimensions.

IRRATIONALS
The use of irrational or root proportions in ancient art and architecture was rediscoved by American artist Jay Hambidge in the 1920s. Hambidge called this compositional system "Dynamic Symmetry".

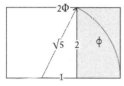

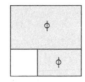

ABOVE: Golden rectangles and squares are made of each other. Rectangles marked φ are Golden.

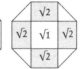

ABOVE: An octagon is made of four √2 rectangles and three squares.

 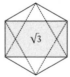 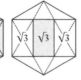

ABOVE: Self similarity. Each √3 rectangle can be divided into three more √3 rectangles.

 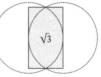

ABOVE: The √3 rectangle appears with two equilateral triangles or two circles.

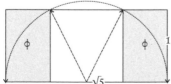

ABOVE: A √5 rectangle emerges from a central square and its arc. The shaded rectangles are golden.

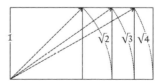

ABOVE: A √4 rectangle equals two squares (themselves √1 rectangles).

RABATMENT
where's the square

What happens when you find the square inside a rectangle? This little-known but highly useful design technique is called *rabatment* (from the French for "folding back", as a cloth collar is folded). The square may be drawn at one end of the rectangle, or at both ends, or in the centre (*opposite top*).

The examples shown (*below and opposite*) demonstrate how the lines of tension created by rabatment can be used to position elements of the composition. The rectangle remaining after rabatment has its own mathematical characteristics and can be further divided, either by continual rabatment or by other harmonious divisions at crossing points along diagonals and arcs.

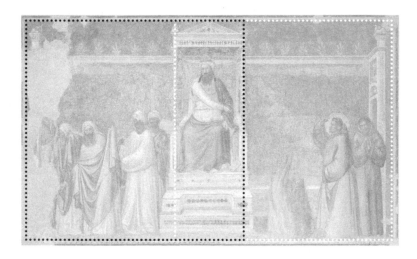

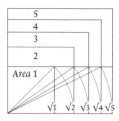

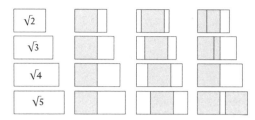

ABOVE: Square root rectangles convert irrational lengths into rational areas.

ABOVE: Root rectangles, showing squares drawn on one side, in the centre, and from both sides. The internal placement of a square inside a rectangle creates important lines of tension.

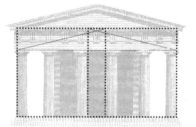

ABOVE LEFT: The Poppy Field, Claude Monet, 1881. ABOVE RIGHT: Temple of Hephaestus, Athens. BELOW: The Annunciation, Leonardo da Vinci, 1472. FACING PAGE: St Francis Before the Sultan, Giotto di Bondone, 1325. A square from each side frames the throne.

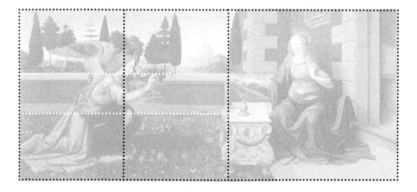

THE ROOT-TWO RECTANGLE
new beginnings

The square (the original 1×1, or √1 "square-root of 1" rectangle) is the most rational of all rectangles. But its diagonal is irrational, having the value √2 or 1.4142... times the length of its sides. Compass arcs allow the diagonal of the square to become the long sides of a √2 rectangle (*below left*), the extension of the mundane square by its diagonal setting the pattern for the construction of further square-root rectangles (*see pages 40-41*). The √2 rectangle, as the "firstborn" rectangle from the square, is a symbol of generation and represents birth and new beginnings, seen in the shape of diplomas and churches.

Dividing a √2 rectangle in half produces two smaller rotated √2 rectangles, whose diagonals cross those of the parent √2 rectangle at right angles. Every subsequent halving of a √2 rectangle contributes to a cascade of smaller and smaller √2 rectangles. This is the advantage of standard International "A" paper dimensions—there is always a √2 envelope to match any number of halfway foldings. The thin rectangle added onto the square that transforms it into a √2 rectangle has an area equal to a smaller, turned √2 rectangle plus a square.

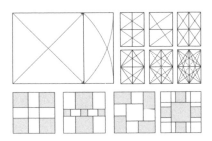
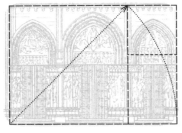

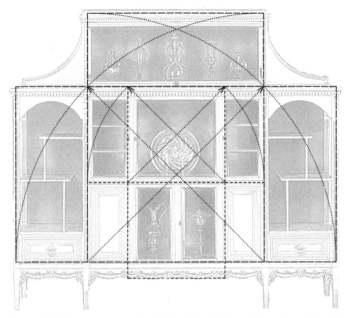

ABOVE: *Gilded drawing room cabinet, designed by the Herter Brothers, New York, 1883.*
FACING PAGE: *Royal Portal, west facade of Chartres Cathedral, completed c.1220.*

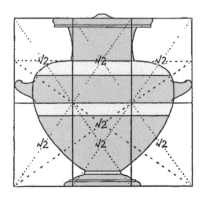

LEFT: *Greek vase designed using √2 proportions. Six √2 rectangles have been employed in the design. Halving a √2 rectangle produces two √2 rectangles, and the designers has used this to set the base of the neck. Illustration by Jay Hambidge. The way the √2 rectangle works with the square is surpassed only by the golden rectangle (see pages 52-57). These lines have offered guidance to countless artists, designers and architects over the centuries.*

Root-Two Proportions
architectural applications

A circle drawn around a square of edge length 1 has a diameter equal to √2. As such, the root two proportion connects the circle with to the square, symbolising the marriage of Heaven and Earth.

If you want to draw a circle and a square so that they are equivalent in length, then a square side 11 and a circle diameter 14 do the job, since the square will have perimeter 44 and, with π as 22/7, the circle will have circumference 44. To create a circle and square with the same approximate area, make your square side 8 and your circle diameter 9.

The symbolism of the square and the circle make them perfect partners in architecture, which also bridges the above and the below.

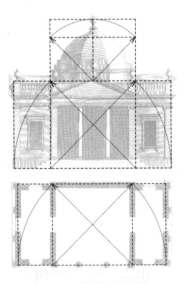

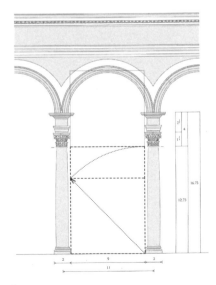

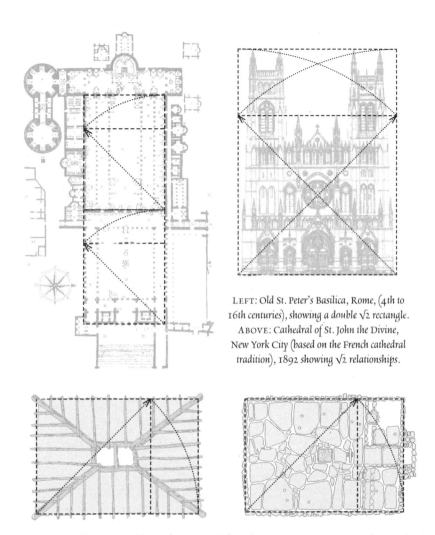

LEFT: Old St. Peter's Basilica, Rome, (4th to 16th centuries), showing a double √2 rectangle. ABOVE: Cathedral of St. John the Divine, New York City (based on the French cathedral tradition), 1892 showing √2 relationships.

ABOVE: Native American kiva roof structure and floor plan. FACING PAGE LEFT: Architectural elevation and plan drawing by James Gibbs, 1728, whose designs influenced Thomas Jefferson's Montecello; RIGHT: Nave Arch, San Lorenzo, Florence, design by Filippo Brunelleschi c.1420.

THE ROOT-THREE RECTANGLE
sacred tri-unity

The √3 rectangle is an ambassador for the symbolism of three, conveying strength, mediating balance, and sacred transcendence (√3 = 1.732...).

The √3 rectangle expands the proprotions of the equilateral triangle. A √3 rectangle divided into three equal parts produces three smaller turned √3 rectangles (*e.g. see examples opposite top left and bottom right*). The diagonals of these small √3 rectangles cross the diagonal of the parent rectangle at right angles (*bottom left*). Further subdivisions maintain this ratio and right-angle crossings.

Three √3 rectangles, each rotated by 60° produce a regular hexagon (*shown, below left, in a vesica piscis, the shape between two overlapping circles*).

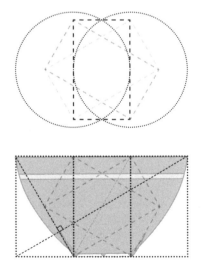

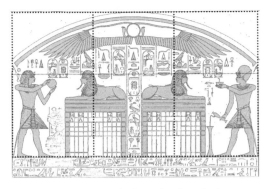
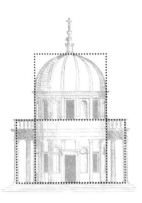

ABOVE LEFT: Dream Stele of Egyptian Pharaoh Thutmose IV, 18th Dynasty, 1401BC. *The stele is framed by a √3 rectangle divided into thirds; a rabatment dividing the top and bottom sections.* RIGHT: Bramante's Tempietto of San Pietro in Rome uses horizontal and vertical √3 rectangles.

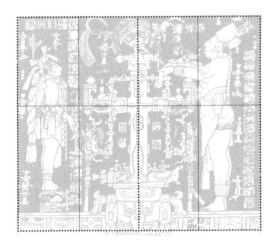
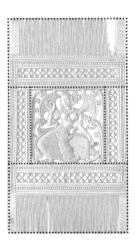

ABOVE: LEFT: *Mayan priests performing a ritual. Two root-3 rectangles, each halved with rabatment.* RIGHT: *Ivory comb with a dancing woman, Sri Lanka, 18th century.* FACING PAGE: LEFT: *Greek cup.* RIGHT: *Egyptian Stele of priests of Ha-hat, c.600BC. Again we observe the highly-prized principle of "unity underlying diversity" at work.*

THE ROOT-FOUR RECTANGLE
the art of the double square

The √4 rectangle, or double-square, projects a sense of strength, stability and authority. For example, the 2nd century BC, grand entrance pylon of the great temple at Edfu, Egypt, built between 237 BC and 57 BC, is based on a double-square (*see below*). The plan of the White House, in Washington, DC, is also based on a double-square, with golden section internal divisions on its second floor (*opposite top*).

The diagonal of a double square makes an angle of 26.565° with the long side, an angle which appears widely in ancient architecture, for example as the aligment of the Temple of Luxor in Egypt, and as the the angle of slope of the Grand Gallery inside the Great Pyramid. The diagonals of quadrupal squares were also used at Giza. The diagonal angle of a triple square is 18.435°, and this is found in the 6,000-year-old alignments of menhirs at Le Menec West, in Carnac, France.

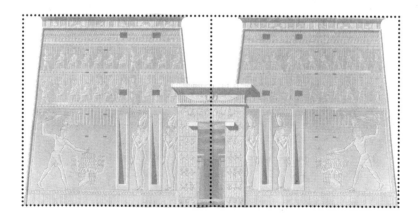

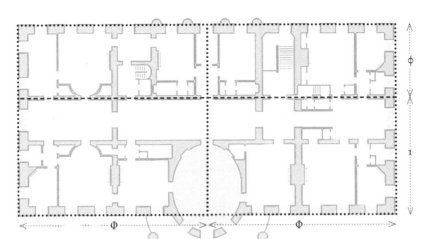

ABOVE: The White House, Washington, DC. BELOW LEFT: Cartouche of Ramesses II's throne name (User-maat-re, 'Ruler of Everything Encircled by the Sun'), Abu Simbel, Egypt.

BELOW: Fifth Century Greek Bronze Mirror, Musuem of Fine Arts, Boston.

BELOW: Arabic Qur'un page on paper, China, c.1600, showing quartered double-squares. FACING PAGE: Grand pylon of the great Temple at Edfu, Egypt.

THE ROOT-FIVE RECTANGLE
a golden expanse

The √5 rectangle is a door into the *golden ratio (see pages 30 & 54)*, and is thus another symbol of life and regeneration. It can be drawn from the diagonal across a double-square (or √4 rectangle) *(below, a.)*. It appears widely in art and architecture as a square flanked by two upright golden rectangles *(below, b.)*, and it can also be drawn as a horizontal golden rectangle plus its own small turned √5 inverse *(below, c.)*. It is also seen in geometric constructions of two √5 rectangles and two small squares (a √4 rectangle) within a circle *(e.g. below right)*.

√5 (=2.236...) is often mistaken for the nearby module of 9:4 (=2.25). For example, scholars argue whether the facade and ground plan of the Parthenon employ a 9:4 or a √5 rectangle *(front cover)*. Villa Emo *(opposite, top right)*, designed by Andrea Palladio, employs a play on the rational 9:4 version, as a central square framed by a pair of 5:8 rectangles (themselves rational approximations to golden rectangles).

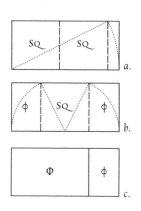

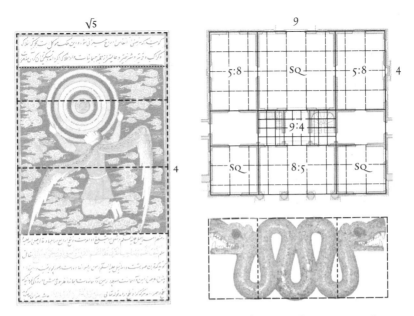

√5

9

SQ

5:8

5:8

4

9:4

SQ

8:5

SQ

4

ABOVE LEFT: The Angel Ruh holding the Celestial Spheres (c.1550-1600). TOP RIGHT: Floor plan of Villa Emo, by Palladio, c.1560. ABOVE RIGHT: Double-headed turquoise serpent, Aztec, 15th-16th C. BELOW: Vishnu with Lakshmi resting on Shesha Nag, King of Serpents, from the Atha Naradiyamahapuranam. FACING PAGE: Buddhist vision of Heaven and Hell, c.1800.

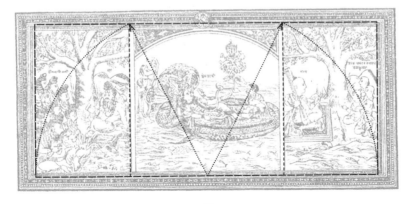

THE GOLDEN RECTANGLE
nature's favourite

The *golden rectangle* has been described as the most beautiful of all rectangles. It lies between the $\sqrt{2}$ and $\sqrt{3}$ rectangles, and emerges from the semi-diagonal of a square (*below left*), both as a small golden rectangle added to the square and as the new larger rectangle. Adding or removing a square to or from a golden rectangle simply produces another larger or smaller rotated golden rectangle.

The golden ratio, $(1+\sqrt{5})/2 = 1.618...$, is naturally proportional, as $2.618:1.618 :: 1.618:1 :: 1:0.618$. It is often approximated by Fibonacci ratios, such as $5/3$ ($1.666...$) or $8/5$ (= 1.6) or $13/8$ (= 1.625). The golden ratio thus effortlessly relates all parts with each other and the whole. Since nature uses Fibonacci numbers in leaves and flowers, the golden rectangle represents life and growth.

The diagonal of any golden rectangle crosses the diagonal of its smaller inverted golden rectangle at right angles, at its *occult centre* (*see page 19*), the eye of the spiral.

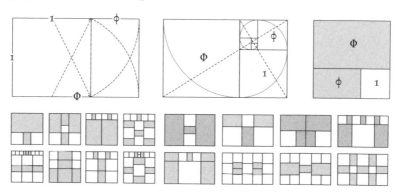

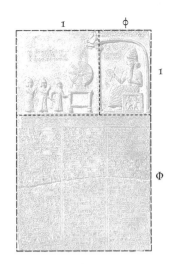

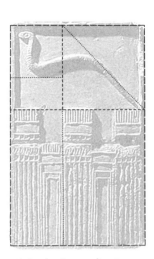

LEFT: *Tablet of the sun-god Shamash, Sippar, Babylon (southern Iraq), c. 870BC.*
RIGHT: *Detail from the Stele of the Royal Serpent, tomb of Djet, Abydos, Egypt, c.3000BC.*

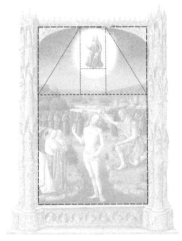

LEFT: *Baptism of Christ, Limbourg brothers, Bourges, France, c.1430.* RIGHT: *Bay, a "Servant in the Place of Truth", created this "Hearing Ear" stele to speak to the deities, Egypt, c. 1200BC*

GOLDEN PROPORTIONS
the beauty of self-symmetry

The golden ratio relies on only one rule: the whole is to the large part as the large part is to the small part. Described as the "extreme and mean ratio" by Euclid [c.325-265 BC] golden proportions appeared in art and architecture millennia earlier, as ancient artists, architects, designers and engineers found a tool for marshaling the great and small into one harmonious whole.

The simple secret of immense value is that every golden rectangle is made of a square plus a golden rectangle, and every square is made a golden rectangle plus a smaller golden rectangle and a square. Due to this self-referencing property, squares and golden rectangles effortlessly transform into combinations of each other in a seamless interplay of weightless elegance.

The golden ratio appeals because it always remains itself—it has the virtue of self-remembrance of its own ratio. The feeling of beauty we recognize and respond to in the golden ratio is due to its charming mathematical self-reflection, something we recognize in our own depths. Its self-referential nature reminds us that unity underlies apparent multiplicity, a consistent theme of traditional art and architecture.

 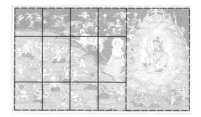

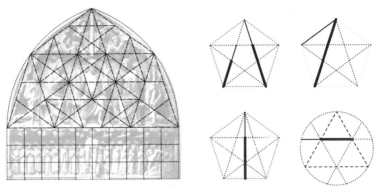

ABOVE LEFT: *The Last Judgement, south transept, central portal, Chartres Cathedral, France.* ABOVE RIGHT: *The golden section in a pentagram, and in a circle. In each case the ratio between the thin solid line and the thick solid line is* φ:1 *or* 1:Φ, *where* φ = 0.618... *and* Φ = 1.618...

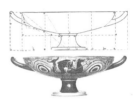

LEFT: *Egyptian scarab brooch.*
RIGHT: *Greek kylix wine cup:*
BELOW: LEFT: *Celtic belt clasp,*
Iberia, c150BC; CENTRE:
Decorated pylon portal; RIGHT:
Egyptian Alabaster jar, c. 1330BC.

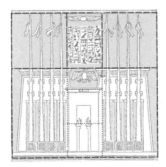

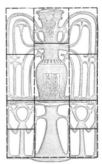

FACING PAGE LEFT: *Tantric yoga practitioner being purified in fire while gazing on the kundalini serpent.* FACING PAGE RIGHT: *Prince Subuddhi (a heroic ancestor of the Rathore dynasty) meets Shiva in the Forest of Illusion. Gouache on handmade paper.*

PROPORTIONAL QUOTATIONS

"The good, of course, is always beautiful, and the beautiful never lacks proportion. ... [Designers should] fix their eyes on perfect truth [maths] as a perpetual standard of reference, to be contemplated with the minutest care, before they proceed to deal with earthly canons about things beautiful."
– Plato [c.426–348/347BC]

"No ornament, only proportion."
– St. Bernard of Clairvaux [1090–1153]

"Painting is a science and all sciences are based on mathematics." – Leonardo da Vinci [1452–1519]

"Inspiration, even passion, is indeed necessary for creative art, but the knowledge of the Science of Space, of the Theory of Proportions, far from narrowing the creative power of the artist, opens for him an infinite variety of choices within the realm of symphonic composition."
– Matila Ghyka [1881–1965]

"I have come to know that Geometry is at the very heart of feeling, and that each expression of feeling is made by a movement governed by Geometry."
– Auguste Rodin [1840–1917]

"... the same numbers by means of which the agreement of sounds affect our ears with delight are the very same which please our eyes and our minds."
– Leone Battista Alberti [1404–1472]

"... And since geometry is the right foundation of all painting, I have decided to teach its rudiments and principles to all youngsters eager for art ..."
– Albrecht Dürer [1471–1528]

"Regulating lines ... are ... a springboard and not a straightjacket. They satisfy the artist's sense ... and confer on the work a quality of rhythm."
– Le Corbusier [1887-1965]

"Knowledge of a basic law gives a feeling of sureness which enables the artist to put into realization dreams which otherwise would have been dissipated in uncertainty."
– Jay Hambidge [1867-1924]

"... Every part is disposed to unite with the whole, that it may thereby escape from its incompleteness."
– Leonardo da Vinci [1452-1519]

"The mathematical sciences particularly exhibit order, symmetry, and limitation; and these are the greatest forms of the beautiful."
– Aristotle [384–322BC]

"Without mathematics there is no art."
– Fra Luca Pacioli [1445–1517]

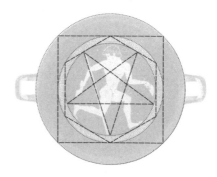